D1101437

THE
SCHOOL
OF
MANNERS.
OR
RULES for Childrens Behaviour:

LONDON.

Printed for *Tho. Cockerill,* at the
ThreeLegs andBible againſt Gro-
cers-Hall in the *Poultrey,* 1701

THE
SCHOOL
OF
MANNERS.
OR

RULES for Childrens
Behaviour:

At Church, at Home, at Table,
in Company, in Discourse, at
School, abroad, and among
Boys. With some other
short and mixt Precepts.

By the Author of the *English
Exercises.*

The Fourth Edition.

LONDON.

Printed for *Tho. Cockerill*, at the
Three Legs and Bible against Gro-
cers-Hall in the *Poultrey*, 1701

This book was designed and produced by
The Oregon Press Limited, Faraday House,
8–10 Charing Cross Road, London WC2H 0HG
for the Victoria and Albert Museum

Design by Laurence Bradbury

0–905209–36–2

Printed and bound by
BAS Printers Limited,
Stockbridge, Hampshire

Introduction.

The present little book is both more, and less, than the original publication. It is less because it is in fact only half of the author's text, which was issued in Latin as well as English. It is more, because the original volume was unillustrated, and so the pictures that appear in this edition have in fact been selected from a variety of later sources. The writer identifies himself on the title page only as 'the author of the English Exercises'. He was in fact John Garretson, but beyond his name and his authorship of these two books, almost nothing is known about him. From the preface to The School of Manners we may deduce that he was a schoolmaster, and from the subject matter

of the two books we may presume that Latin was his main subject, although he does not appear to have attended either Oxford or Cambridge universities. English Exercises *went through many editions during the* 18th *century, but by* 1727 *a new preface refers to 'the late author' of the original work, so presumably he was dead by then.* English Exercises *was obviously quite a popular work (with schoolmasters anyway!), and the British Library has a number of different editions, although the earliest there is the* 11th *edition of* 1707*. The* School of Manners *is much rarer: there is no copy in the British Library and the one reprinted here is taken from the 4th edition in the Library of the Victoria and Albert Museum, London.*

In his preface to The School of

Manners *the author explains his reason for issuing the text in two languages: it was in order that it might reach as wide a range of pupils as possible, from those who have just 'learned to read' to 'lads of greater proficiency' in Latin. But in either language the intention is the same, namely to expound 'rules for children's behaviour: at church, at home, at table, in company, in discourse, at school, abroad, and among boys'—in other words it is a direct descendant of the 'courtesy books' of the Middle Ages. As such*

it would have been quite familiar, in many of its aspects, to the young page in a medieval castle, who began his long climb up the ladder to knighthood by learning how to comport himself in contemporary society.

One of the obvious differences between the earlier courtesy books and the one reprinted here was that the later one is no longer meant for the few nobly born boys, but is intended to reach a wide range of middle class children. In telling the pupil what he should not do as well as what he ought to do, the author gives us a vivid picture of 17th-century social conventions and an intimate portrayal of daily life. Some of the instructions reveal a formality that has long passed away: the boy should not only bow to strangers but also to his parents,

*and never sit in their presence with-
out leave.*

Since The School of Manners *was primarily a school textbook it is not surprising that it was unillus-trated. It was not until the second half of the 18th century that books for children, in the form that we know them, began to appear on the market in any number. The illus-trations that accompany the present edition have therefore been taken from a number of later sources, though all of them, like* The School of Manners *itself, can be found in the Library of the Victoria and Albert Museum. Most of them date from the last quarter of the 18th century, by which time many books began to appear that claimed to be 'for the amusement' as well as 'the instruction of little masters and misses'. But although*

some of the pictures have been taken from books intended for the occupants of the middle and upper class nurseries, many of them are taken from chapbooks, which were aimed at humbler audiences. Early books for children were produced by the cheapest method available; such pictures as they contained were often by hack artists and reproduced as woodcuts. Sometimes the illustrations bore little relation to the text and might be used over and over again in different books.

The stories at this period were still highly moral and educational, and their titles suggest that they were obviously addressed more to the adult who would actually buy the books (then as now!) rather than the child who would be given them. The chapbooks, however, were sold at the lowest price—about 1p of

modern money—and their illustrations reflect this fact. These little books, with their crude pictures, were carried around by the pedlar or 'chapman' from farmstead to farmstead, and village to village, together with ribbons and laces, broadsheets and ballads—and the latest news. They were aimed at the unsophisticated reader quite as much as at the child, rather like many of today's comic strips. In spite of their cheapness and naïveté, they did have an important part to play in the history of children's literature. Only rational reading was allowed in the middle and upper class nurseries for some decades following the publication of Rousseau's Emile, ou l'éducation in 1762. It was chapbooks alone which, as a substratum of literature, kept alive the fairy tales,

the folk tales, and the nursery rhymes, which might otherwise have been lost to children. When in the 19th century there was a gradual change in the attitude to the child and his reading, the world of imagination and fantasy was still there, waiting to be rediscovered and so enchant succeeding generations of children.

Joyce Irene Whalley
January 1983

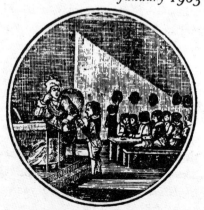

The Preface.

AMONG the various Accomplishments wherewith Parents expect that Children under the Schoolmasters care, should be competently furnished, That of decent Carriage and Behaviour is no less necessary and ornamental, than universally demanded. Nor is it an unreasonable expectation in those, that willingly are at great expences for the good and wholsome Education of their offspring in good letters, that besides the bare acquisition of Learning, they should understand something of ingenious and obliging conversation, to distinguish them from the unpolished and illiterate Rout, and honourably to grace their other excellent At-

tainments. *A Scholar ill bred
and rude in his behaviour*, is
the disgrace and reproach of his
Master, who usually, and some-
times deservedly, is reflected on,
as being by his negligence some-
thing worse than the occasion of
that ugly and mishapen deformi-
mity, in a nature, which by ex-
acter care might have been clo-
thed with a delightful comli-
ness.

He is the fretting Disease
of his Parents discontented
mind, who if they be persons of
good and ingenious breeding,
cannot but with hainous resent-
ment observe in their Children
(whom they would fain have
their own Image, in Mind as
well as in Body) a Carriage so
hatefully unlike their own: If
they themselves be the sad in-
stances of a defect of this na-

ture, yet that mannerly Decency
whereof themselves are igno-
rant, like every other excellent
thing, commands admiration,
and in others converse, especial-
ly of their own Children, is a
very pleasing accomplishment.
When he is afterwards grown
to riper years, he is the distem-

pered member of the Family,
wherein Providence shall cast
his lot ; and how desirable soever
upon every other account , how
much soever he may seem to me-
rit for faithful and good ser-
vices, yet must be discouraged
by neglect and contempt of su-
periors and equals.

And no less burthensome will
he be, and despicable in the fu-
ture scenes of his life, unless the
charitable care of some after-
friend supply the defects of for-
mer education, or his own ge-
nerous industry, by careful imi-
tation of worthy Examples ,
wrest himself from the dis-
grace, which must otherwise
fatally oppress him.

That these intolerable incon-
veniences may be prevented, is
no question, or ought to be the
passionate desire of Parents, and

*the faithful labour of Tutors;
the relation of each sort of per-
sons obliging them to an affecti-
on and care for Children, and
neglecting nothing that may ac-
complish and adorn their better
part, and tend to their future
happiness.*

And that the proper and pe-
culiar part, both of *Parents* at
Home, and *Masters* at School,

towards the good and accomplish-
ed educating of youth, as to
Manners. may be the more easy,
their desires and endeavours the
more successful, is the design of
this little Tract, occasioned by
a long and troublesome obser-
vation of Childrens rudeness in
behaviour, both at home and a-
broad, and of Parents perpetu-
al intreaties, tiring the instru-
ctors of their Children with
importunate demands, That
they sollicitously inculcate to
them that part of Learning,
those documents which may tend
to mend and reform them.

It may be reckoned amongst
the vulgar errors, That too ma-
ny suppose the whole care of
their Children ought to be thrust
upon the Master, and that Pa-
rents may totally neglect them;
but it is high time for them to

*be sensible that there is a part
to be done by them, which is no
less necessary than reasonable;
and 'twere to be wished that they
would consider, That Masters
undergo much more bootless and
unprofitable toil, than would
otherwise be requisite, if Parents
would second the great attempt,
and not grudge their auxiliary
labours about those things which
are within their sphere. As for
other parts of Education, they
shall very readily, (I had almost*

said thankfully) be excused. But this care of *Manners* is a Task that may very fairly, and must be divided, and the Master still bear a very competent burthen.

It is hoped the smalness of the *Volume*, and the brevity of the *Precepts* will not expose, but recommend a *Treatise* of this nature, to those who know and consider the backwardness of *Children* to study, and the slippery deceit of their memories; and that the smaller parcel of work they have imposed upon them, if it be compleat, and as large as their necessities, it will probably be the more readily and effectually done; nor, I suppose, is the cheapness of a *Book* to some *Parents* an inconsiderable *Excellency*.

It was thought requisite that it should be done both English

and Latin. *In the Mother
Tongue, that none might be be-
low a capacity of being benefit-
ed thereby, that have Learned
to Read ; And in the Learned
Language, that Lads of greater
proficiency might not think it
below them ; and that it might
be for the more general use,
being if Masters think fit)
sometimes Learned as a* Latin
Author as well as barely read

over for admonition; which
course may Imprint the Precepts
the more firmly in their memo-
ries. But I transgress, if I pre-
tend to direct the Masters pru-
dence, how to use it, which will
unquestionably be more than
sufficient.

Instead of such a presumpti-
on, on the contrary, the whole
is submitted to the candid plea-
sure of those who shall not dis-
dain to make use of it, whose
Wisdom will easily suggest apt
methods for rendring it to all
Children in their several capa-
cities advantagious, supplying
its defects, passing over its er-
rors, not with rigid, but favour-
able censure. Only doing the
Author so much Justice as to be-
lieve, That in this little Enter-
prise the aim unfeignedly was
only to commit something to

Paper (with as much fulness
and brevity as were well compa-
tible) which might be a faith-
ful and constant Monitor to
Children, of that Decency in be-
haviour, and universal converse,
which their Parents with good
reason expect from them; which
will every where gain them ap-
plause, esteem and admiration;
the respect of all that know
them, and that praise which will
abundantly recompence some lit-
tle extraordinary pain and care,
which they shall employ in con-
versing in (besides their other
parts of Education) the
SCHOOL of MANNERS.

THE
SCHOOL
OF
MANNERS.

CHAP. I.

Short and mixt Precepts.

1. FEAR GOD.
2. Honour the KING.
3. Reverence thy Parents.
4. Submit to thy Superiors.
5. Despise not thy inferiors.
6. Be courteous with thy Equals.
7. Pray daily and devoutly.
8. Converse with the Good.

9. Imitate not the wicked.

10. Hearken to Instruction.

11. Be desirous of Learning.

12. Love the School.

13. Be always cleanly.

14. Study Vertue.

15. Provoke no Body.

16. Love thy Schoolfellows.

17. Please thy Master.

18. Let not play entice thee.

19. Restrain thy Tongue.

20. Covet future Honour, which only Vertue and Wisdom can procure.

CHAP. II.

Of Behaviour at the Church.

1. DEcently walk to thy Seat or Pew; run not, nor go wantonly.

2. Sit where thou art ordered by thy Superiors, Parents, or Masters.

3. Shift not Seats, but continue in the same place.

4. Lend thy place for the easing of any one that stands near thee.

5. Keep not too long a Seat lent thee by another, but being eased restore it.

6. Talk not in the Church, especially in the time of Prayers or Preaching.

7. Fix thine eye upon the Minister; Let it not wildly wander to gaze upon any Person or Thing.

8. Attend diligently to the Words of the Minister; pray with him when he prayeth, at

leaſt in thy Heart; and while he
preacheth, liſten, that thou mayeſt
remember.

9. Be not haſty to run out of
the Church when the Worſhip is
ended, as if thou wert weary of
being there.

10. Walk decently and ſoberly
home, without haſt or wanton-
neſs.

CHAP. III.

Of Behaviour at Home.

1. ALways bow at coming Home; and be immediately uncovered.

2. Be never covered at home, especially before thy Parents or Strangers.

3. Never sit in the presence of thy Parents without bidding, though no Strangers be present.

4. If thou pass by thy Parents, or by any place where thou seest them, either by themselves, or with Company, bow towards them.

5. If thou be going to speak to thy Parents, and see them engaged in Discourse or Company, draw back, and leave thy business till afterward; but if thou must speak, be sure to whisper.

6. Never speak to thy Parents, without some Title of Respect, *viz.* Sir, Madam, Forsooth; &c.

according to their quality.

7. Approach near thy Parents at no time without a Bow.

8. Dispute not, nor delay to do thy Parents Commands.

9. Go not forth of doors without thy Parents leave, and return within the time by them limited.

10. Come not into the room where thy Parents are with strangers unless thou be called, and then decently; and at bidding, go out; or if strangers come in while thou art with them, it is man-

nerly with a bow to withdraw.

11. Use respectful and courteous, not insulting or domineering carriage or language towards the Servants.

12. Quarrel not, nor contend with thy Brethren or Sisters, but live in Love, Peace, and Unity.

13. Grumble not, nor be discontented at any thing thy Parents appoint, speak or do.

14. Bear with Meekness and Patience, and without murmuring or sullenness, thy Parents Reproots or Corrections, nay, though it should so happen that they be causeless or undeserved.

CHAP. IV.

Of Behaviour at the Table.

1. COME not to the Table
 unwash'd or not comb'd.

2. Sit not down till thou art
bidden by thy Parents or Supe-
riors.

3. Be sure thou never sit till
Grace be said, and then in thy
due place.

4. Offer not to carve for thy
self, or to take any thing, though
it be what thou ever so much de-

firest.

5. Ask not for any thing, but tarry till it be offered thee.

6. Find not fault with any thing that is given thee.

7. When thou haft meat given thee, be not the firft to begin to eat.

8. Feed thy felf with thy two Fingers, and the Thumb of the left hand.

9. Speak not at the Table; if thy Superiors be difcourfing, meddle not with the matter.

10. If thou want any thing from the Servants, call to them

softly.

11. Eat not too fast, or greedily.

12. Eat not too much, but moderately.

13. Eat not so slow as to make others wait for thee.

14. Make not a noise with thy tongue, mouth, lips, or breath, either in eating or drinking,

15. Stare not in the face of any one (especially thy Superior) at the Table.

16. Grease not thy Fingers or Napkin, more than necessity requires.

17. Bite not thy bread, but break it, but not with slovenly Fingers, nor with the same wherewith thou takest up thy meat.

18. Dip not thy Meat in the Sawce.

19. Take not salt with a greazy Knife.

20. Spit not, cough not, nor blow thy Nose at Table if it may be avoided; but if there be necessity, do it aside, and without much noise.

21. Lean not thy Elbow on the Table, or on the back of thy Chair.

22. Stuff not thy mouth so as to fill thy Cheeks; be content with smaller Mouthfuls.

23. Blow not thy Meat, but with Patience wait till it be cool.

24. Sup not Broth at the Table, but eat it with a Spoon.

25. Smell not to thy Meat, nor move it to thy Nose; turn it not the other side upward to view it upon the Plate.

26. Throw not any thing under the Table.

27. Hold not thy Knife upright in thy hand, but lay it down at thy right hand with the Blade upon thy plate or trencher.

28. Spit not forth any thing that is not convenient to be swallowed, as the Stones of Plums, Cherries, or such like; but with thy left hand neatly move them to the side of thy plate or trencher.

29. Fix not thine eyes upon the plate or trencher of another,

or upon the meat on the Table.

30. Lift not up thine eyes, nor roll them about, while thou art drinking.

31. Foul not thy Napkin all over, but at one corner only.

32. Bend thy Body a little downwards to thy plate, when thou movest any thing that is sauced, to thy mouth,

33. Look not earnestly on any one that is eating.

34. Foul not the Table-Cloth.

35. Gnaw not Bones at the Table, but clean them with thy knife (unless they be very small ones) and hold them not with a whole hand, but with two fingers.

36. Drink not, nor speak with any thing in thy mouth.

37. Put not a bit into thy mouth, till the former be swallowed.

38. Before and after thou drinkest, wipe thy lips with thy Napkin.

39. Pick not thy Teeth at the

Table, unless holding up thy
Napkin before thy mouth with
thine other Hand.

40. Drink not till thou have
quite emptied thy Mouth, nor
drink often.

41. Frown not, nor murmur
if there be any thing at the Table
which thy Parents or Strangers
with them eat of, while thou thy
self hast none given thee.

42. As soon as thou shalt be
moderately satisfied, or whenso-
ever thy Parents think meet to bid

thee, rife up from the Table, though others thy Superiors fit ftill.

43. When thou rifeft from Table, take away thy Plate, and having made a bow at the fide of the Table where thou fateft, withdraw, removing alfo thy Seat.

44. When Thanks are to be returned after eating, return to thy place, and ftand reverently till it be done, then with a bow withdraw out of the Room, leaving thy Superiors to themfelves, unlefs thou be bidden to ftay.

CHAP. V.

Rules for Behaviour in Company.

1. ENTER not into the Company of Superiors without command or calling; nor without a bow.

2. Sit not down in prefence of Superiors without bidding.

3. Put not thy hand in the pre-

sence of others to any part of thy
body, not ordinarily discovered.

4. Sing not nor hum in thy
mouth while thou art in company.

5. Play not wantonly like a
Mimick with thy Fingers or Feet.

6. Stand not wriggling with
thy body hither and thither, but
steddy and upright

7. In coughing or sneesing make
as little noise as possible.

8. If thou cannot avoid yawn-
ing, shut thy Mouth with thine
Hand or Handkerchief before it,
turning thy Face aside.

9. When thou blowest thy Nose,
let thy Handkerchief be used, and
make not a noise in so doing.

10. Gnaw not thy Nails, pick
them not, nor bite them with thy
Teeth.

11. Spit not in the Room, but in
a corner, and rub it out with thy
Foot, or rather go out and do
it abroad.

12. Lean not upon the Chair of
a Superior, standing behind him,

13. Spit not upon the fire, nor sit too wide with thy Knees at it.

14. Sit not with thy legs crossed, but keep them firm and settled, and thy Feet even,

15. Turn not thy back to any, but place thy self conveniently, that none be behind thee.

16. Read not Letters, Books, nor other Writings in Company, unless there be necessity, and thou ask leave.

17. Touch not nor look upon the Books or Writings of any one, unless the Owner invite or desire thee.

18. Come not near when another Reads a Letter or Paper.

19. Let thy Countenance be moderately chearful, neither laughing nor frowning.

20. Laugh not aloud, but silently Smile upon occasion.

21. Walking with thy Superior in the house or Garden, give him the upper or right hand, and walk not just even with him cheek be

joll, but a little behind him, yet
not fo diſtant as that it ſhall be
troubleſome to him to ſpeak to
thee, or hard for thee to hear.

22. Look not boldly or wifhful-ly in the Face of thy Superior.

23. To look upon one in com-pany and immediately whifper to another is unmannerly.

24. Stand not before Superiors with thine hands in thy pockets, fcratch not thy Head, wink not with thine Eyes, but thine Eyes modeftly looking ftraight before thee, and thine Hands behind thee.

25. Be not among Equals fro-ward and fretful, but gentle and affable.

26. Whifper not in company.

CHAP VI.

Rules for Behaviour in Discourse.

1. AMONG Superiors speak not till thou art asked.

2. Hold not thine Hand nor any thing else before thy Mouth when thou speakest,

3. Come not over-near to the person thou speakest to.

4. If any one, thy Superior, speak to thee while thou sittest, stand up before thou give thine answer.

5. Sit not down again till thy Superior bid thee.

6. Speak neither very loud nor too low.

7. Speak clear, not stammering nor stumbling.

8. Answer not one that is speaking to thee till he have done.

9. Loll not when thou art speaking to a Superior, or spoken to by him.

10. Speak not without *Sir*, or any
other title of respect, which is due
to him to whom thou speakest.

11. Strive not with Superiors in
Argument or Discourse, but easily

submit thine opinion to their asser-
tions.

12. If thy Superior speak any
thing wherein thou knowest he is
mistaken, correct not, nor contra-
dict him, nor grin at the hearing
of it, but pass over the error with-
out notice or interruption.

13. Mention not frivolous nor
little things among grave Persons
or Superiors.

14. If thy Superior drawl or
hesitate in his words, pretend not
to help him out, or prompt him,

15 Come not near two that
are whispering or speaking in se-
cret, much less mayest thou ask
about what they confer.

16 When thy Parents or Ma-
ster speak to any Person, speak
not thou, nor hearken to them.

17. If thy Superior be relating a
Story, say not, *I have heard it before* ;
but attend as if it were to three alto-
gether new ; seem not to question
the truth of it ; if he tell it not right,
snigger not , nor endeavour to help

out or add to his relation

18. If any immodest or obscene thing be, spoken in thy hearing, smile not at it, but settle thy countenance as though thou didst not hear it.

19. Boast not in discourse of thine own wit or doings.

20. Beware thou utter not any thing hard to be believed.

21. Interrupt not any one that speaks, though thou be his familiar.

22. Coming in, in the midst of a discourse, ask not what was talk't of, but listen to the remainder.

23. Speaking of any distant Person, it is rude and unmannerly to point at him,

24. Laugh not in or at thine own story, wit, or jest.

25. Use not any reproachfull Language, or contemptuous, to any person, though ever so mean, or inferior.

26. Be not over earnest in talking to justify and avouch thy own sayings.

27. Let thy words be modest and about those things only which concern thee.

28. Repeat not over again the words of a Superior that asketh thee a Question, or talketh to thee.

CHAP. VII.

Of Behaviour in the School.

1 BOW at coming in, Putting off thine hat; especially if the Master or Usher be present.

2. Loiter not, but immediately take thine own seat; and move not from one place to another, till School time be over.

3. If any stranger come into the School, rise up and bow, and sit down in thy place again, keeping a profound silence.

4. If the Master be discoursing in the School with a stranger stare not confidently on them, nor hearken to their talk.

5. Interrupt not the Master while a Stranger or Visitant is with him, with any question, request or complaint ; but defer any such matter till he be at leasure.

6. At no time talk or quarrel in the School ; but be quiet, peaceable, and silent : Much less mayest thou deceive thy self by trifling away thy time in play.

7. If thy Master speak to thee, rise up and bow, making thine answer standing.

8. Bawl not aloud in making complaints: A Boys tongue should be never heard in School but in answering a question, or repeating his lesson.

9. If a stranger speak to thee

in School, stand up and answer
with respect and ceremony, both
of words and gesture, as if thou
spakest to thy Master.

10. Make not hast out of the
School, but soberly go when thy

turn comes, without noise or hurry.

11. Go not rudely home
through the street, stand not
talking with boys to delay thee,
but go quietly home, and with all
convenient haste.

12. Divulge not to any person
whatsoever elsewhere, any thing
that hath passed in the School,
either spoken or done.

CHAP. VIII.

Rules for Behaviour Abroad.

1. GO not singing or whistling along the Street; none accustom themselves to that Practice, but those that are of sordid and lowest Education;

2. Quarrel not with any body thou meetest.

3. Affront no one, especially thy elders, by word or deed.

4. Jeer not any person, though thou know some common reproach whereby they have usually, (and it may be deservedly,) been vext and provoked.

5. Always give the Wall to thy Superiors, that thou meetest; or if thou walkest with thy elder, give him the upper-hand, but if three walk together, the middle place is most Honorable.

6. Give thy Superior leave to pass before thee, in any narrow place, where two cannot pass at once.

7. If thou go with thy Parents, Master, or any Superior, go not wantonly, nor even with them, but a little behind them.

8. Pay refpects to all thou meet-
eft of thine acquaintance or friends.
 9. Put off thy Hat to Perfons
of Defert, Quality, or Office, fhew

thy reverence to them by bowing thy Body when thou seest them; and if it be the King, a Prince, Noble, or Magistrate, stay thy self till they be passed by.

10. If a Superior speak to thee in the Street, answer him with thy head uncovered, and put not on thy Hat till he either go from thee, or bid thee twice or thrice be covered; take not leave at the first bidding, but with a bow, and [*by no means, Sir,*] modestly refuse it.

11. Run not hastily in the street, nor go too slowly: wag not to and fro, nor use any antick or wanton posture either of thy head, hands, feet or body.

12. Stare not at every unusual person or thing which thou seest.

13. Throw not any thing in the street, dirt, stones, &c.

14. If thou meet the Scholars of any other School, jeer not, nor affront them, but quietly let them pass.

15. Especially affront not the

M_{aster} of another School; but ra-
ther if thou know him, or if he
live near either thine House or
School, uncover thine Head to
him, and, bowing paſs by him.

CHAP. IX.

Of Behaviour among Boys.

1. AS near as may be, converse not with any but those that are good, sober and virtuous; Evil communication corrupts good Manners.

2. Be not quarrelsom, but rather take patiently, than mischievously occasion any manner of wrong.

3. Reprove thy Companions as often as there shall be occasion for any evil, wicked unlawful, or indecent Action or Expression.

4. Give always place to him that excelleth thee in Quality, Age or Learning.

5. Be willing to take those words or actions as jestings, which thou hast reason to believe were designed for such: and fret not at thy companions innocent mirth.

6. If thy Companion be a little too gross or sarcastical in speaking,

yet ſtrive not to take notice of it,
or be moved at all therewith.

7. Abuſe not thy Companion
either by word or deed.

8. Deal juſtly among boys, thy
equals; as ſolicitouſly as if thou
wert a man with men, and about
buſineſſes of higher importance.

9. Be not ſelfiſh altogether, but
kindly, free, and generous to others.

10. Jog not the Table or Desk
on which another writes.

11. At play make not thy Hands,
Face, or Cloaths, duſty or dirty:

nor fit upon the ground.

12. Avoid finful and unlawful Recreations : all fuch as prejudice the welfare either of body or mind.

13. Scorn not, Laugh not at any for the natural infirmities of Body or mind, nor becauſe of them affix to any a vexing title of contempt and reproach.

14. Adventure not to talk with thy companions about thy Superiors, to raiſe diſcourſe reflecting upon, or touching another's Parents, or Maſter : to publiſh any thing of thine own Family or Houſe-hold affairs. Children muſt meddle only with the affairs of Children.

CHAP. X.

The Concluſion.

THESE (deareſt Treaſures of your tender Parents) are the chief of thoſe Rules of Behaviour, the obſervation whereof will deli-

ver you from the disgraceful titles of *sordid* and *clownish*, and entail upon the mention of you the honour of *gentile* and *well bred* Children: There is scarcaly any more ill sight than a clownish and unmannerly Scholar. Avoid therefore with the greatest diligence so vile an ignominy. Be humble, submissive, and

obedient to those, whose authority by Nature or Providence, hath a just claim to your subjection; such are Parents, Masters or Tutors, whose commands and laws have no other tendency than your truest good; be always obsequious and

respectful, never bold, slighting or
sawcy, either in words or gestures.
Let your body be on every occasi-
on pliable, and ready to manifest
in due and becoming Ceremonies
the inward reverence you bear to-
ward those above you: By this
means, by a timely and early accu-
stoming your selves to a sweet and
spontaneous obedience in your
lower station and relations, your
minds being, habituated to that
which is so indispensably your du-
ty, the task of obedience in far-
ther relations will be performed
with the greatest ease and plea-
sure. When it shall please God
that you come to riper years, and
under the circumstance of Servants,
owe homage to your Masters, and
at length if it shall seem good to
the Divine Providence that you
arrive at Manhood, and become
Members of the Common-wealth,
there will remain in your well-
managed minds no presumptuous
folly, that may in the least prompt

oz tempt you to be other than
faithful, obedient and Loyal Sub-
jects.

Be kind, pleasant, and loving,
not crofs or churlish to your E-

quals; for so shall all exceedingly
covet and admire your familiar ac-
quaintance; every one will be
ready and willing upon opportuni-
ty to serve and assist you; your
friends will be no fewer than all that
know you & observe the excellence
and sweetness of your deportment:
This practice also by inducing an

habit of obliging will fit you for
converse and society, and facilitate
and advantage you dealing with
men in riper years.

Be meek, courteous, and affa-
ble to your Inferiors, not proud
or scornful; to be courteous to

the meanest is a true index of a
great and generous mind; but the
insulting and scornful Gentleman
usually hath been himself original-
ly low, ignoble, or beggerly:
makes himself to his Equals ridi-
culous; and by his Inferiors is re-
payed with hatred, scorn and con-
tempt.

By carefully observing these me-
thods of life, your Superiors will

tender and esteem you, your In-
feriors honour and admire you;
your Equals delight in and love
you; all that know and observe
you, shall praise and respect you;
your example shall be propounded
as a pattern of ingenuity and ob-
liging behaviour; you shall be va-
luable and well esteemed in every
time, station, and circumstance of
your lives : you shall be blest with
the names of good Children, good
Scholars, good Servants, good Ma-
sters, and good Subjects : Praise
shall be your attendant all your
lives long, and your Names shall
outlive the envy of the Grave, the
Encomium of every Survivor shall
embalm your Memory.

List of illustrations

The illustrations in the present reprint have been taken from a number of books, which are listed below in alphabetical order of title, since most of them were published anonymously. The page numbers refer to the position of the pictures in the present work, and not to their place in the original publication.

Blossoms of morality intended for the amusement and instruction of young ladies and gentlemen. *Cuts by J. Bewick. London: E. Newbery ,1796, p. 29*

Divine songs in easy language for the use of children. *By I. Watts. London: J. Evans & Son* [c. *1820?*], *pp. 7, 27 (top), 30, 47, 49, 62*

The history of the Goodville family; or, the rewards of virtue and filial duty. *London: A. Millar [and others]* [c. *1795*], *pp. 33, 35*

The history of Tommy Playlove and Jacky Lovebook. Wherein is shown the superiority of virtue over vice, however dignified by birth or fortune. *Glasgow: J. Lumsden & Son, 1819, pp. 12, 15, 21*

Jemima Placid; or, the advantage of good nature exemplified in a variety of familiar incidents. *Third edition. London: J. Marshall & Co.* [*1786?*], *p. 32*

Morals to a set of fables, by Mrs Teachwell. The morals in dialogues between a mother and her children. *London: J. Marshall & Co.* [*1783*], *p. 56*

The mother's gift; or, a present for all little children who are good. *Second edition. London: Carnan & Newbery, 1770, p. 58*

Poems on various subjects for the amusement of
youth. *London: J. Marshall & Co. [1783],
pp. 1, 17,37*

Progress of man and society . . . opening the
eyes and unfolding the mind of youth gradually.
*By the Rev. Dr. Trusler. London: J. Trusler,
1791, p. 60*

The renowned history of Primrose Prettyface
who by her sweetness of temper and love of
learning was raised from being the daughter of
a poor cottager to great riches, and the dignity
of lady of the manor [etc]. *London: J. Marshall
& Co. [c. 1795]. pp. 19, 31*

The triumph of goodnature exhibited in the
history of Master Harry Fairborn and Master
Trueworth. Interspersed with tales and fables.
*Glasgow: J. Lumsden & Son [1810?], pp. 2,
41, 44, 52*

The Valentine's gift; or, a plan to enable
children of all denominations to behave with
honour, integrity, and humanity. To which is
added Some account of old Zigzag and of the
horn which he used to understand the language
of birds, beasts, fishes, and insects. *Glasgow:
J. Lumsden & Son [c. 1815?], pp. 51, 54*

Watts' Divine songs in easy language for the use
of children. *Glasgow: J. Lumsden & Son
1820?], pp. 27 (bottom), 61*

The way to be happy; or, the history of the
family at Smiledale. To which is added, The
story of little George. *Glasgow: J. Lumsden &
Son, 1819, pp. 25, 42*